Edgar

Degas

By Norma Broude

RIZZOLI ART SERIES

Series Editor: Norma Broude

Edgar
Degas
(1834–1917)

Images of Women; Images of Men

EDGAR DEGAS was an artist who was extraordinarily open and sensitive to the social transformations, complexities, and ambiguities of his own period. His art, we might say, was constituent of ideologies and life-styles in transition during the late nineteenth century. This may help to explain why Degas's art has become such a lightning rod for our own society, for we continue to see reflected in it many of our own ambivalences and unresolved social dilemmas.

While Degas is today among the most popular of all nineteenth-century artists, his works are at the same time among the most widely misunderstood and hotly contested. A prime organizer and participant in seven of the eight independent exhibitions that brought Impressionism to light and eventually to prominence as an avant-garde movement in France between 1874 and 1886, Degas has become inscribed in public consciousness as an "Impressionist," even though he resisted that label and preferred to be called an "Independent" or a "Realist." Degas differed fundamentally, in fact, from artists such as Claude Monet and Camille Pissarro, who painted their subjective responses to nature out-of-doors and maintained the romantic commitment to spontaneity (or at least the appearance of it) in their works as a critical sign of artistic originality and sincerity. Unlike the landscape painters, whom the more astute critics of the period were already calling "the real Impressionists," Degas took as his focus the human figure and, through it, the depiction of contemporary life. Deeply rooted in traditional artistic values and in particular the study of the Italian Renaissance, he remained firmly committed not only to representing the human figure but also to drawing and to studio practice. And while his pictures may produce the effect of the unplanned, the momentary view or action immediately glimpsed, they are entirely calculated to do so. Their effects are the result of his careful planning and very deliberate procedures. "No art," Degas said, "was ever less spontaneous than mine. What I do is the result of reflection and study of the great masters."[1]

Yet Degas's art fascinates us today for its modernity on several grounds. In formal terms, he was remarkably open to technical experimentation and to unconventional uses of traditional media, as evidenced by his pastels, monotypes, etchings, and sculptures (most notably the famous *Little Fourteen-Year-Old Dancer*, fig. 1, which is modeled in wax and adorned with real hair and clothing). And while he continued to grapple with traditional perspectival constructions in many of his pictures, he would typically exaggerate or

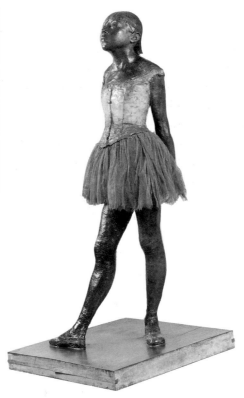

1. *The Little Fourteen-Year-Old Dancer.*
1879–1881. Wax, cotton skirt, satin hair ribbon, hair now covered with wax, height: 37½". Collection of Mr. and Mrs. Paul Mellon, Upperville, Virginia

radically modify them, adopting odd angles of vision to produce steeply tilted floor planes and overlapping forms and figures. These vivid fragments are often cropped unexpectedly as they meet the frame and seem to move beyond the spatial confines of the picture. Degas embraced the new modes of viewing that were suggested in this period by photography and Japanese prints, thus loosening the singular possessive gaze of the one-point perspective system to create the mobile and more widely inclusive "slice-of-life" vision that has become so inextricably identified today both with the imaging of modern life and with modernity.

In the closely related and interdependent realm of subject matter, Degas is perhaps most widely known to the art public in the twentieth century through his popular and numerous racetrack and ballet scenes, many of them generic works that he produced out of practical and commercial necessity in response to the tastes and demands of a growing market for these subjects both in France and abroad. But his major focus from his early career on was the portrait—for the most part non-commissioned portraits of family and friends—which he used more effectively than any other artist of his period as a vehicle for the exploration of the social and psychological situation of the individual in modern life.

Many of Degas's portraits are in fact indistinguishable from contemporary genre scenes and vice versa. For example, *The Orchestra of the Opéra* (plate 9) is in reality a portrait of Degas's friend, the bassoonist Désiré Dihau, who is presented here in the setting and activity that most fully characterize him, as he performs at the Paris Opéra. In *At the Races in the Countryside* (plate 7), a few horses race across the field in the distance, but go unnoticed by the occupants of a stationary carriage in the foreground. There Degas's childhood friend Paul Valpinçon and his wife are enacting a vignette of contemporary upper-middle-class life: they watch their hired wet nurse, sheltered from the sun beneath an umbrella, as she feeds their infant son, Henri (only the family bulldog appears to be watching the race). Several of the men scattered casually around the table bearing cotton

samples in *Portraits in an Office (The Cotton Market, New Orleans)* (plate 5) are members of Degas's family. In the fall of 1872 he had visited New Orleans, where his mother had been born and where his uncles had established themselves as cotton merchants. Here, we see one of the uncles, Michel Musson, seated in the foreground testing a sample of cotton between his fingers in a gesture that defines and characterizes him in terms of his profession. And in the picture that Degas exhibited at the fourth Impressionist group exhibition in 1879 under the title *Portrait of Friends in the Wings* (plate 11), the well-dressed men in top hats who stand and talk with one another backstage in a theater are Ludovic Halévy, a prominent opera librettist, who was another of Degas's old friends from his school days, and Albert Cavé, a well-connected devotee of the theater.

In concept and composition, these paintings have little to do with the traditional portrait. But they are portraits and group portraits nevertheless, portraits of specific people who are no longer conceived as lifeless and artificial objects posed before the artist's easel but who are instead set literally into life. As the creator of such images and as a major driving force behind the radical conceptual shift in nineteenth-century art that they represent, Degas was clearly the model and inspiration for Edmond Duranty's description of the innovative accomplishments of the new figure painters of his day. In a pamphlet entitled *The New Painting,* published in April 1876 on the occasion of the second group exhibition of the Impressionists, Duranty, a novelist and critic who had championed the Realist art of Gustave Courbet in the 1850s and who had been a follower of the naturalist novelist Emile Zola and a friend of Degas's since the mid-1860s, now declared:

> We will no longer separate the figure from the background of an apartment or the street. In actuality, a person never appears against neutral or vague backgrounds. Instead, surrounding him and behind him are the furniture, fireplaces, curtains, and walls that indicate his financial position, class, and profession. The individual will be at a piano, examining a sample of cotton in an office, or waiting in the wings for the moment to go on stage, or ironing on a makeshift table. . . . When at rest, he will not be merely pausing or striking a meaningless pose before the photographer's lens. This moment will be a part of his life as are his actions.[2]

Like his friend Duranty, Degas was intensely interested in theories of physiognomic expression, an interest that in his case took its initial impetus from traditional, even academic, artistic concerns and practices and a desire both to build upon these practices and to reform them so that they might now serve as expressive instruments suitable to the modern era. In a notebook entry dating from about 1868–1872 Degas wrote: "Make of the *tête d'expression* (in academic parlance) a study of modern feelings." Referring to the popular and still influential work of the eighteenth-century Swiss philosopher and physiognomist Johann Kaspar Lavater, who had classified inherited cranial and facial types and proposed these as a predictive indicator of personality types, Degas continued: "It is Lavater, but a Lavater more relative as it were, with accessory symbols at times."[3]

Both Duranty and Degas were critical of the reductive tendencies of older theorists of physiognomic expression,

and they sought a wider context of social, cultural, and also physical indicators for use by modern artists and writers. Duranty, whose lengthy article "On Physiognomy" appeared in 1867, commented explicitly on the central role of physiognomic expression in the work of the new figure painter in his pamphlet of 1876: "A back should reveal temperament, age, and social position, a pair of hands should reveal the magistrate or the merchant, and a gesture should reveal an entire range of feelings. Physiognomy will tell us with certainty that one man is dry, orderly, and meticulous, while another is the epitome of carelessness and disorder."[4]

Nevertheless, Duranty's theory, like the older ones, depended upon the assumption of a codifiable and universally legible system of external signs for the reading of character and personality. Degas, too, often relied on the sometimes caricatural abstractions that could result from such physiognomic typing. But his involvement with portraiture fostered in him an attentiveness to individual variation and to personal psychology that often belied the categorizable external signs, thus introducing into many of his images an ambiguity of reading that tempered and undermined the pseudoscientific practices and assumptions of nineteenth-century theories of physiognomic expression and ultimately threatened to dismantle them.[5]

Far more than we have realized, Degas may be regarded as what the French would call an *artiste engagé,* an artist whose work, in the tradition of David and Daumier, was inflected by and at times may even have addressed itself directly to topical social issues, a concern that would also have aligned him with the naturalist writers of his period. These writers often selected their subjects and settings from the lower strata of society, and their systematic exploration of what were deemed to be the sordid and ugly or criminal and immoral aspects of contemporary life was normally justified by critical supporters in the nineteenth century for its instructive value in teaching a moral lesson. Degas's identification with this point of view in the years around 1880 is suggested, among other things, by his decision to exhibit at the sixth Impressionist group exhibition in 1881 his startling wax sculpture *The Little Fourteen-Year-Old Dancer* (fig. 1), with its tinted wax body, real cloth garments and wig, and glass exhibition case (which suggested to observers, perhaps deliberately, the scientific display of an ethnographic specimen), along with two pastels entitled *Physiognomies of Criminals* (now lost), which were based on his own courtroom drawings of the young principals in a shocking and highly controversial recent murder trial. Contemporary critics decried the "ugliness" of *The Little Dancer.* And they were especially struck by similarities in facial type between the adolescent girl and the accused murderers, inferring from the exaggeratedly low foreheads and "simian" jaws with which Degas had deliberately endowed these young people a Darwinian reference to "lower," less-evolved forms of human life in general and to a genetically inherited criminal character in particular. In the context of topical and heated scientific debates of this period over the nature of criminality and the question of its sources in heredity and/or environment, the critics who thus responded to Degas's work were taking the position of such criminologists as the Italian Cesare Lombroso, whose influential classifications of criminal anatomy and physiognomy first appeared in a study

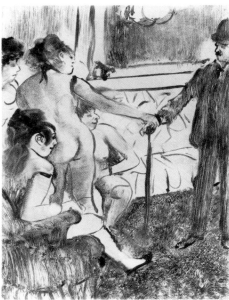

2. *The Reluctant Client*. c.1878–1879. Monotype on wove paper, plate: 8¼ × 6¼". National Gallery of Canada, Ottawa

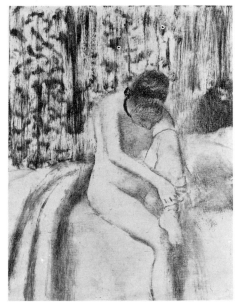

3. *Girl Putting On Her Stocking*. c.1878–1879. Monotype in black ink on heavy paper, plate: 6⁵⁄₁₆ × 4¹¹⁄₁₆". The Metropolitan Museum of Art, New York. H. O. Havemeyer Collection, Bequest of Mrs. H. O. Havemeyer, 1929

entitled *Criminal Man* in 1876) and apparently assumed that Degas did too.[6]

But the responses of the critics may not be an accurate index of Degas's own position in the environment-versus-heredity debates that raged in his time nor of his intentions in juxtaposing these particular works at the same exhibition. For if this pairing is viewed as providing contrast rather than analogy, one might derive from it an entirely different reading of the young dancer (described respectfully by Degas in one of his sonnets as "this brand-new little being, with her bold demeanor"),[7] whose life-style and social lineage may have made her morals stereotypically suspect in this society but who was nevertheless a hardworking and independent survivor. Such a reading could be used to make a case against the idea that heredity, as revealed by physiognomy, is a predictive indicator of criminal or immoral behavior, and to place responsibility for these social ills instead at the doorstep of society and its exploitative practices.

This reading of the pairing and Degas's intentions in making it finds further support in the artist's uses of physiognomic typing in his series of brothel monotypes (e.g., figs. 2 and 3).[8] This series of more than fifty extant images was created in the late 1870s, at a time when feminist activists (including Degas's friend the Italian critic and social commentator Diego Martelli) were calling for an end to the system of state-regulated prostitution and the closing of government-licensed brothels. This system, they said, not only denied women their human and civil rights but also sanctioned and supported behavior—on the part of men—that threatened the stability of the family and the state. Against the official order's self-serving characterization of prostitutes as women who must be kept separated from the rest of society because they were "bestial" and "other" by hereditary nature, Degas's unprecedented images of life within these state-regulated brothels might be read instead as an anti-regulationist statement that undermined the pseudoscientific rationales behind which nineteenth-century society tried to hide and to justify its patterns of exploitation.[9] Thus, as though to reinforce the point, the series occasionally includes an image of an unclothed woman who is youthful and relatively idealized (fig. 3). Still physically unmarked by the life

into which she has been economically trapped, she is identifiable as a prostitute only by virtue of an external attribute, such as a pair of stockings or a black ribbon worn around her neck.[10] In the majority of these images, Degas continued to make use of the aberrational physiognomics that played such an important role in the anthropological and sociological debates of his period. But he did so to characterize not only the prostitutes but also their respectably dressed middle-class customers. They, too, are presented by Degas as dehumanized and grotesque, and they sometimes share with the prostitutes in these images the de-centered and off-balance posture that Lombroso had identified as a prime characteristic of the criminal physiognomy in general and of the female prostitute in particular (fig. 2).[11]

Over the last two decades of this century, both Degas's images of women and his attitudes toward them have become a prime subject in the Degas literature.[12] We should consider, however, that the "obsession with women," attributed by recent writers to Degas,[13] may be as much our own and his society's as his. Although he was not necessarily either, Degas was called a "misogynist" by some and a "feminist" by other nineteenth-century commentators who were discomfited by his unorthodox images of women, images that seemed to signal an unwelcome disruption in the existing social fabric.[14] Degas came to maturity in a gender-segregated and power-imbalanced society whose art had traditionally helped to construct women as objects of male desire and possession or as pedestal madonnas whose identities depended wholly on the patriarchal notion of the family. But it was also, increasingly, a modern urban world of work and entertainment, in which women were joining the workforce in unprecedented numbers. Women supported commerce and industry not only as producers and sellers of commodities, but also, with increasing and critical economic importance, as consumers. And in Degas's day, women were banding together in still small but noticeably disruptive numbers to decry the social costs of gender inequality and exploitation and to demand equity in education, in the workplace, and in laws governing marriage and property.

By the late 1870s and 1880s these societal changes and the tensions and conflicts they engendered were an

increasingly visible part of the modern world that Degas set out to interpret. Their impact, as one context for Degas's art, may be suggested by the history of his *Spartan Girls Challenging Boys* (plate 3). Begun about 1860, at the start of Degas's career, as a traditional history painting based on such literary sources as Plutarch, this work's already unusual subject was inspired by the atypically egalitarian Spartan custom of encouraging adolescent girls and boys to exercise publicly in one another's company. Around 1879–1880, a time when the return of liberal republican control of the senate and the presidency in France encouraged a controversial resurgence and escalation of feminist activism in the political sphere, Degas decided to revise this now potentially timely picture, planning to show it at the fifth Impressionist group exhibition, in 1880. The revised version—in which contemporary Parisian types replace originally classicizing figures and the boys at the right assume newly wary and confrontational stances vis-à-vis their female challengers—is a picture that now asks to be read in terms of the contemporary relationship between the sexes, a relationship that was being redefined not only by women's escalating demands for the creation of a more equitable social order but also by men's responses to those demands.[15]

What is striking, in fact, given our present-day critical fixation on Degas's images of women, is that we ignore the role of men in his art and the sensitivity—in many instances equal to that shown in his depictions of women—with which he presented them as they too grappled with the challenges and discomforts of shifting roles and identities in the modern world. For example, his group portrait of the members of the Bellelli family (plate 2), based on studies executed while he was the guest of his aunt and uncle in Florence during the fall and winter of 1858–1859, has long been recognized as the image of a troubled and divided family.[16] The young painter's sympathy and affection clearly resided with his unhappy aunt Laura, who is shown here pregnant and in mourning for her recently deceased father. She is spatially and emotionally distanced in this image from her husband, the Baron Bellelli, whose political activities as a supporter of the Piedmontese statesman Camillo Benso di Cavour in the struggle for Italian independence during the Revolution of 1848 had caused the family to be exiled from their Neapolitan home.[17] But at the same time Degas presents a clear-sighted and not necessarily unsympathetic interpretation of his uncle's estranged position in this family group. Pushed to the peripheries of the picture and seen only in shadowy profile, the Baron's absorption in his public duty and his estrangement from the family whose pain and dislocation that duty had caused are reminiscent of Jacques-Louis David's *Brutus* (1789; Paris, Musée du Louvre), a neoclassical prototype whose message Degas may well have set out here to modernize. In the center of Degas's work, Giulia, the more independent of the two Bellelli daughters, occupies a pivotal position between her parents. And her evident, albeit ambivalent, attraction to her otherwise isolated father may mirror the attraction that Degas himself might have felt for this compelling and still active man, who would later serve, after national unification, as a senator in the newly established Kingdom of Italy, and whose political radicalism placed him at the opposite pole from the conservatism of Degas's own father, who was a banker. It was undoubtedly through the Baron Bellelli that Degas was introduced to the stimulating

and socially diverse crowd of artistic and political radicals who gathered at the Caffè Michelangiolo in Florence at this time, a formative experience that permitted the young French artist, temporarily freed from paternal supervision, to explore a variety of social, political, and artistic options that would not then have been possible for him at home.[18]

Degas's self-portrait with Evariste de Valernes (plate 1) is another rare but telling image in the artist's early oeuvre. Accustomed to his father's circle of cultivated friends, Degas in his youth often sought out friendships with men who were older than himself, such as Valernes, who was eighteen years his senior. In the years around 1855, when they met, Valernes, who was a painter and former student of Delacroix, may have helped to broaden Degas's tastes in the direction of the painterly and coloristic, weaning him away from his earlier, narrow commitment to the disciples of Ingres. In this double portrait painted about 1865 Degas does in fact appear to have cast himself in the role of a hesitant disciple, positioning himself behind the relaxed and assured figure of his dapper but impecunious friend, whose reputation would soon be eclipsed by his own. In his recessive position in this pairing and in the hand lifted tentatively before his face to mediate the cool or perhaps defensive gaze that he directs toward the viewer, Degas's choice of self-image here is clearly echoed in the portrait that he painted in the same year of his sister, Thérèse, in her dependent relationship with her husband Edmondo Morbilli (a painting now in the Museum of Fine Arts, Boston).

Degas's portraits of men were usually of sitters who belonged to his own social class or intellectual circle, men with whom he could closely and easily identify. These included family members, such as the remarkably tender portrait of Degas's elderly father, Auguste de Gas, shown lost in reverie as he listens to the music of the Spanish singer Lorenzo Pagans (c.1871–1872; Paris, Musée d'Orsay). More poignant still is the late portrait of Degas's lifelong friend Henri Rouart (plate 15). In a composition perhaps modeled after Titian's *Portrait of Pope Paul III and His Grandsons* (1545–1546; Naples, Museo di Capodimonte; copied, we know, by Degas in his youth),[19] Rouart is seated very low in the picture space, physically dominated in old age by his son, Alexis, whose unstable posture and unfocused gaze make him seem inadequate as a replacement or even as a guardian for his once vital and robust father.

In a different vein, Degas sometimes painted the images of men whose friendship or acquaintance had helped to define particular moments in his life, such as the *Portrait of Jeantaud, Linet, and Lainé* (1872; Paris, Musée d'Orsay), an animated reunion of three young businessmen who had served with him as national guardsmen in the defense of Paris during the Franco-Prussian War. In 1879 he painted the portraits of two writers and critics whom he found intellectually compatible, Edmond Duranty (Glasgow, The Burrell Collection) and Diego Martelli (Edinburgh, National Gallery of Scotland), portraying each of them at a desk in an attitude calculated to signal mental concentration and creativity. Degas's portraits of artists who were his friends convey through a variety of means the personalities, problems, and concerns of these men with whom he would have naturally identified. In the most enigmatic of these, *The Artist Henri Michel-Lévy in His Studio* (plate 10), Degas suggests the creative dilemmas that may have plagued his friend, a painter

of contemporary outdoor pastoral subjects who appears to have maintained a traditional studio practice. Virtually as a demonstration of the artifice that Degas himself believed to be essential to the art of painting, Michel-Lévy is shown, withdrawn and moody, leaning against the wall of his studio between one of those "outdoor" paintings and a stuffed mannequin, which seems to have served him as a studio model for that painting. The mannequin, doubly removed from life, is ironically more animate in appearance than is Michel-Lévy in Degas's rendering.

While intimate depictions of mothers and children have long been a staple of art and artists in the Western tradition (from the madonnas of the Renaissance to the happy mothers of eighteenth- and nineteenth-century bourgeois art), the subject of fathers and children, and in particular fathers and daughters, has always been a rare and unusual one outside the realm of the formal family portrait. Though no less rare, notable exceptions to the rule appear in the late nineteenth century, predictably in the work of such women artists as Mary Cassatt (her portrait of her brother, *Alexander J. Cassatt and His Son, Robert Kelso Cassatt,* 1884; Philadelphia Museum of Art) and Berthe Morisot (depictions of her husband, Eugène Manet, overseeing their young daughter, Julie, at play outdoors, dating from the early 1880s).

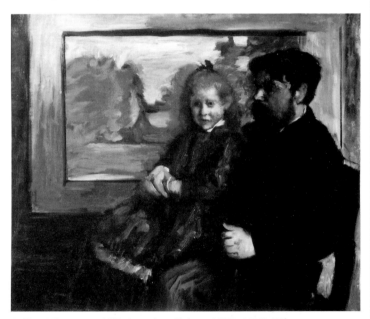

4. *Henri Rouart and His Daughter Hélène.* 1871–1872. Oil on canvas, 25 × 29½". Private collection. Photograph by Malcolm Varon, New York, ©1986

Predating these, however, and uniquely defying the cultural stereotypes, Degas painted a series of pictures in the early 1870s in which he began to explore the nature of fathering as a role for men in the modern world in general and the complexities of the father-daughter relationship in particular, a subject in which he had already shown some interest in the Bellelli family portrait in the late 1850s. The first of these, painted c.1871–1872, was inspired by his reunion in the early 1870s with his old school friend, Henri Rouart, who was to be depicted by Degas during these years both in his public persona as a successful engineer and industrialist (*Henri Rouart in Front of His Factory,* c.1875; Pittsburgh, The Carnegie Museum of Art) and also in his private role as an affectionate father, with his young daughter Hélène seated on his lap (fig. 4). A very different and far more poignant relationship is depicted in Degas's portrait of his uncle, Henri de Gas, an elderly bachelor who had suddenly been

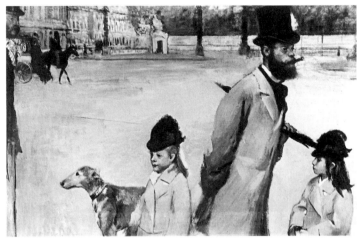

5. *The Vicomte Lepic and His Daughters in the Place de la Concorde, Paris.* c.1875. Oil on canvas, 31⅛ × 46⅛". Formerly in the Gerstenberg Collection, Berlin, destroyed

called upon to act *in loco parentis* to his orphaned young niece, Lucie de Gas. In the sensitive portrait known as *Uncle and Niece* (The Art Institute of Chicago), painted in about 1876, when Degas was visiting his family in Naples, the wistful little girl, still dressed in mourning, leans tentatively on the back of the chair in which her uncle sits and reads. Both look up as though suddenly interrupted, suggesting that this is not a staged tableau but a normal moment in their new domestic life. And in *The Vicomte Lepic and His Daughters in the Place de la Concorde, Paris* (fig. 5), father and daughters are portrayed as urban sophisticates, clearly related to one another in costume, manners, and tastes. Grouped asymmetrically at the right in this public space, they are shown physically united for the moment as a family group while at the same time each is responding to a separate stimulus. Evoking the sensations of physical closeness and relatedness on the one hand and independence and instability on the other, the composition brilliantly conveys something of the situation of the individual in modern life, both in relation to the family group and to the urban environment.

In Degas's depictions of men working and socializing in the relatively privileged world of cotton offices, stock exchanges, orchestras, or backstage at the theater (plates 5, 9, and 11), and in his images of women in laundries, millinery shops, theaters, cafés, and cabarets (plates 12 and 13), we are presented with striking statements about the separate worlds of women and men and the extent to which they functioned in gender-stratified spheres of work and friendship during the nineteenth century. However, there is also to be found in Degas's imagery noticeable departures from and even reversals of expected gender roles and high-art stereotypes—for example, men whose identities are presented, still atypically, in terms of private family relationships and women who are identified with their work in the public sphere.

These and other reversals and expansions of the iconographically and socially expected, reflective certainly of a newly evolving but still contested social reality in Degas's time and even our own, are perhaps at the root of our continuing ability, more than a century later, to go on identifying with and being challenged by Degas's images—images of women and images of men.

NOTES

(For short citations, refer to Further Reading)

1. Conversation reported in George Moore, "Degas," *Impressions and Opinions* (New York: Scribner's, 1891), pp. 228–229.
2. Edmond Duranty, *The New Painting: Concerning the Group of Artists Exhibiting at the Durand-Ruel Galleries* (1876), in *The New Painting, Impressionism 1874–1886* (San Francisco: Fine Arts Museums of San Francisco; Washington, D.C.: National Gallery of Art, 1986), pp. 44–45.
3. On Degas's longstanding interest in physiognomic expression, see Theodore Reff, *The Notebooks of Edgar Degas: A Catalogue of the Thirty-Eight Notebooks in the Bibliothèque Nationale and Other Collections*, 2 vols. (Oxford: Clarendon Press, 1976), 1: 25–28; Degas's statement is from notebook 23, p. 44 (1: 117), as translated in Reff, *Degas: The Artist's Mind*, p. 217.
4. Duranty, *New Painting* [as in note 2, above], p. 44. Duranty's article, "Sur la Physionomie," appeared in *La Revue libérale* 2 (July 25, 1867), pp. 449–523.
5. On these issues, see Armstrong, *Odd Man Out*, especially chapter 2.
6. See Douglas Druick, "La Petite Danseuse et les criminels: Degas moraliste?" in *Degas inédit, Actes du Colloque Legas* (Paris: Musée d'Orsay, 1988), pp 225–250; also Anthea Callen, "Anatomy and Physiognomy: Degas' Little Dancer of Fourteen Years," in Kendall et al., *Degas, Images of Women*, pp. 10–17.
7. "Ce petit être neuf, à la mine hardie." *Huit Sonnets d'Edgar Degas*, preface by Jean Nepveu-Degas (Paris: Jeune Parque, 1946); translation mine.
8. The brothel monotypes have been catalogued by Eugenia Parry Janis in *Degas Monotypes, Essay, Catalogue, and Checklist* (Cambridge, Mass.: Fogg Art Museum, 1968), checklist nos. 61–118ff; and by Jean Adhémar and Françoise Cachin in *Degas, The Complete Etchings, Lithographs and Monotypes* (New York, 1974), nos. 83–123ff.
9. See Broude, "Degas and French Feminism." While Degas did exhibit some of his bather monotypes in the 1870s, there is no evidence that the brothel scenes (those that can be so classified without ambiguity) were shown. On this and arguments regarding the dating of the monotypes in general and the brothel subjects in particular, see Boggs et al., *Degas*, pp. 258–260; and Broude, "Degas and French Feminism," pp. 649 n. 48, 651–653.
10. In a recent catalogue entry on this monotype, Colta Ives notes that the black ribbon choker was worn by ballet dancers on stage and by prostitutes in the brothel. But despite the curtained bedroom interior that provides the setting for this nude and the improbability that a ballet dancer would sleep in her black ribbon choker or put it on before any other garment, Ives avoids identification of this figure as a prostitute and insists that this young woman "has all the earmarks of a ballerina, in her physical delicacy and agility and in her attention to her feet" (*Splendid Legacy: The Havemeyer Collection* [New York: Metropolitan Museum of Art, 1993], pl. 80, p. 81). Although this reading may also have been the one preferred (or perhaps the only one entertained) by Mary Cassatt, who owned this monotype and gave it to Mrs. H. O. Havemeyer in 1889, the ambiguity of signs in *Girl Putting On Her Stocking* makes it another of Degas's wry subversions of physiognomic stereotyping and interpretation.
11. Cesare Lombroso, *L'Homme criminel* (1876; Paris, 1895), p. 254; and Lombroso, *La Femme criminelle et la prostituée* (Paris, 1896), pp. 38ff, as cited in Armstrong, *Odd Man Out*, p. 280 n. 34.
12. The first to raise these issues were Broude, "Degas's 'Misogyny'" (1977); and Eunice Lipton, "Degas' Bathers: The Case for Realism," *Arts Magazine* 54 (May 1980), pp. 295–313.
13. Kendall et al., *Degas, Images of Women*, p. 6; and Griselda Pollock, in Kendall and Pollock, eds., *Dealing with Degas*, p. 25.
14. For further discussion of the social and interpretative mechanisms involved, see Broude, "Degas's 'Misogyny'" and Broude, "Degas and French Feminism."
15. For this reading of the picture, see Broude, "Degas and French Feminism."
16. Boggs, *Portraits*, pp. 14–15.
17. On the Bellelli family, see R. Raimondi, *Degas e la sua famiglie in Napoli, 1793–1917* (Naples, 1958), pp. 224–244.
18. Despite his conservative family background, Degas's own political orientation, certainly by the 1870s, appears to have been liberal and republican (McMullen, *Degas, Life, Times, and Work*, pp. 188–189). In his later years, by the 1890s, he adopted an ultraconservative and anti-Semitic position in the controversies surrounding the Dreyfus affair, endangering or losing many longstanding friendships in the process (Nochlin, "Degas and the Dreyfus Affair," pp. 96–116).
19. Catalogued by Reff in *Notebooks* [as in note 3, above] and dated 1856–1857, notebook 8, p. 14 (1:57).

FURTHER READING

Armstrong, Carol. *Odd Man Out: Readings of the Work and Reputation of Edgar Degas*. Chicago and London: University of Chicago Press, 1991.

Boggs, Jean Sutherland. *Portraits by Degas*. Berkeley and Los Angeles: University of California Press, 1962.

Boggs, Jean Sutherland, et al. *Degas*. New York: Metropolitan Museum of Art; Ottawa: National Gallery of Canada, 1988.

Broude, Norma. "Degas's 'Misogyny.'" *The Art Bulletin* 59 (March 1977), pp. 97–107. Reprinted in *Feminism and Art History: Questioning the Litany*, eds. Norma Broude and Mary D. Garrard, pp. 246–269. New York: Harper and Row, 1982.

———. "Edgar Degas and French Feminism, ca. 1880: 'The Young Spartans,' the Brothel Monotypes, and the Bathers Revisited." *The Art Bulletin* 70 (December 1988), pp. 640–659. Reprinted in *The Expanding Discourse: Feminism and Art History*, eds. Norma Broude and Mary D. Garrard, pp. 269–293. New York: HarperCollins, 1992.

Kendall, Richard, et al. *Degas, Images of Women*. Liverpool: Tate Gallery Liverpool; London: Tate Gallery Publications, 1989.

Kendall, Richard, and Griselda Pollock, eds. *Dealing with Degas*. New York: Universe, 1992.

Lipton, Eunice. *Looking Into Degas: Uneasy Images of Women and Modern Life*. Berkeley and Los Angeles: University of California Press, 1986.

McMullen, Roy. *Degas, His Life, Times, and Work*. Boston: Houghton Mifflin Company, 1984.

Nochlin, Linda. "Degas and the Dreyfus Affair: A Portrait of the Artist as an Anti-Semite." In *The Dreyfus Affair: Art, Truth, Justice*, ed. Norman L. Kleeblatt, pp. 96–116. Berkeley and Los Angeles: University of California Press, 1987.

Reff, Theodore. *Degas: The Artist's Mind*. New York: Metropolitan Museum of Art; Harper and Row, 1976.

First published in 1993 in the United States of America by Rizzoli International Publications, Inc.
300 Park Avenue South
New York, New York 10010

Copyright ©1993 by Rizzoli International Publications, Inc.
Text copyright ©1993 by Norma Broude

Library of Congress Cataloging-in-Publication Data

Broude, Norma.
 Edgar Degas / Norma Broude.
 p. cm. — (Rizzoli art series)
 Includes bibliographical references.
 ISBN 0-8478-1751-2
 1. Degas, Edgar, 1834–1917—Catalogs. I. Title.
 II. Series.
 759.4—dc20 93-10442
 CIP

Series Editor: Norma Broude

Series designed by José Conde and Betty Lew/Rizzoli
Editor: Charles Miers; Assistant Editor: Jennifer Condon

Printed in Italy

Front cover: See colorplate 8

Index to Colorplates

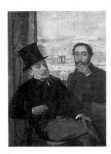

1. *Edgar Degas and His Friend Evariste de Valernes.* c.1865. Degas often used the Renaissance double-portrait format to explore and contrast related personalities. Here he employs gesture, gaze, and position to contrast his own apparently hesitant and skeptical relationship to the outside world with the nonchalant self-assurance of his older friend.

2. *The Bellelli Family.* c.1858–1860 (with later revisions). Based on studies executed in Florence in 1858–1859 when Degas was a guest of his aunt and uncle, this group portrait is a sensitive and psychologically acute portrayal of a strained and divided family.

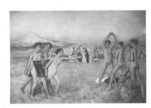

3. *Spartan Girls Challenging Boys.* c.1860/1880. Degas began this work around 1860 as a traditional history painting. Two decades later, in a climate of escalating feminist activism in France, he revised it, giving these figures a more contemporaneous appearance and heightening their confrontational and wary reactions to one another.

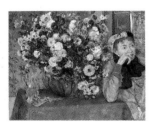

4. *Woman with Chrysanthemums (Madame Paul Valpinçon?).* 1865. Degas has used a bold asymmetrical composition, inspired by Japanese prints, in the service of a psychologically probing, Western-style portrait. The painting's popular misnomer is perhaps an unconscious or oblique acknowledgment on the part of Western observers of this cultural debt, since the chrysanthemum is the imperial flower of Japan.

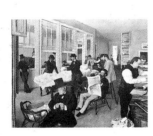

5. *Portraits in an Office (The Cotton Market, New Orleans).* 1873. In the fall of 1872 Degas visited his mother's family in New Orleans. This picture, a result of that trip, is a prime example of the modern group portrait. It presents, with great attention to detail, several of the male members of Degas's family in the familiar activities and professional setting of their family cotton office.

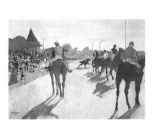

6. *Racehorses before the Stands.* c.1866–1868. In his racetrack scenes, Degas often focused on the horses and jockeys rather than the fashionable crowds. These equestrian figures (here seen in a clearly contemporary landscape with industrial smokestacks rising in the distance) are the modern era's socially disparate version of the processions and parades of the traditional high art that Degas had studied in his youth.

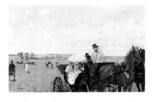

7. *At the Races in the Countryside.* 1869. Apparently an image of upper-middle-class leisure, this scene of a family outing at the races can also be read as a display of the labor that supports such leisure: that of the jockeys racing in the distance and the wet nurse, a working woman of the nineteenth century, nursing her charge in the carriage.

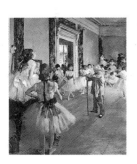

8. *The Dance Class.* c.1873–1876. The dance master in this genre scene and portrait is Jules Perrot, an eminent dancer-choreographer of an earlier period, long retired when he posed for Degas. His figure provides the fulcrum for the dancers, most of whom turn their attention elsewhere or adjust their garments as if in preparation for the rehearsal.

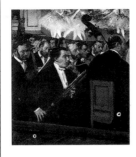

9. *The Orchestra of the Opéra.* c.1870. The orchestra pit, normally regarded as a marginal area in a theatrical performance, here occupies most of the pictorial field and serves as a natural setting for a portrait of Désiré Dihau, bassoonist at the Paris Opéra, and other musical friends of Degas.

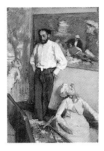

10. *The Artist Henri Michel-Lévy in His Studio.* 1878. Michel-Lévy, son of a prominent publisher, was a painter of contemporary outdoor figure subjects. But unlike the Impressionists, he seems to have worked in the studio from posed models and even mannequins, as this portrait of him by Degas suggests.

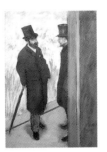

11. *Portrait of Friends in the Wings (Ludovic Halévy and Albert Cavé).* 1879. This is a double portrait of two of Degas's friends who had professional connections with the theater. Featured at the left is Ludovic Halévy, a writer of opera librettos and short stories, who said of the picture when it was exhibited at the fourth Impressionist group show in 1879: "There I am, looking serious in a place of frivolity; just what Degas wanted."

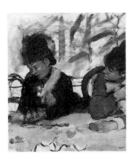

12. *At the Café.* c.1877–1880. This painting captures a moment of quiet and intimate communion between two women in a café and is atypical of Degas's work, in which figures rarely interact with direct solicitude or affection. The shorthand rapidity of the paint application reinforces the impression of a fragile moment quickly registered.

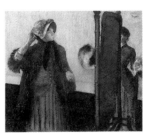

13. *At the Milliner's.* 1882. Degas did a series on milliners, whose traditional and artistic labor, distinct from many other forms of production in the modern world, still involved close contact with both product and client. Mary Cassatt posed as the client who gazes at her reflection in the tall standing mirror that boldly segments this asymmetrical composition.

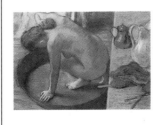

14. *Woman Bathing in a Shallow Tub.* 1886. At the eighth Impressionist exhibition in 1886, Degas showed a series of nudes at their toilette, modern women, representing a wide range of age and class, who are absorbed in their private experiences. Based on unusual formal strategies that externalize and distance the male viewer from the pleasures traditionally afforded by the female nude, these images caused confusion and controversy among Degas's contemporaries.

15. *Henri Rouart and His Son Alexis.* c.1895–1898. Degas, who suffered in later life from weakened eyesight and increasing social isolation, painted a particularly empathetic portrait of his lifelong friend, the aging Henri Rouart. The unusually low placement of the older man in the picture space poignantly conveys his isolation in this pairing, as well as his diminished physical powers.

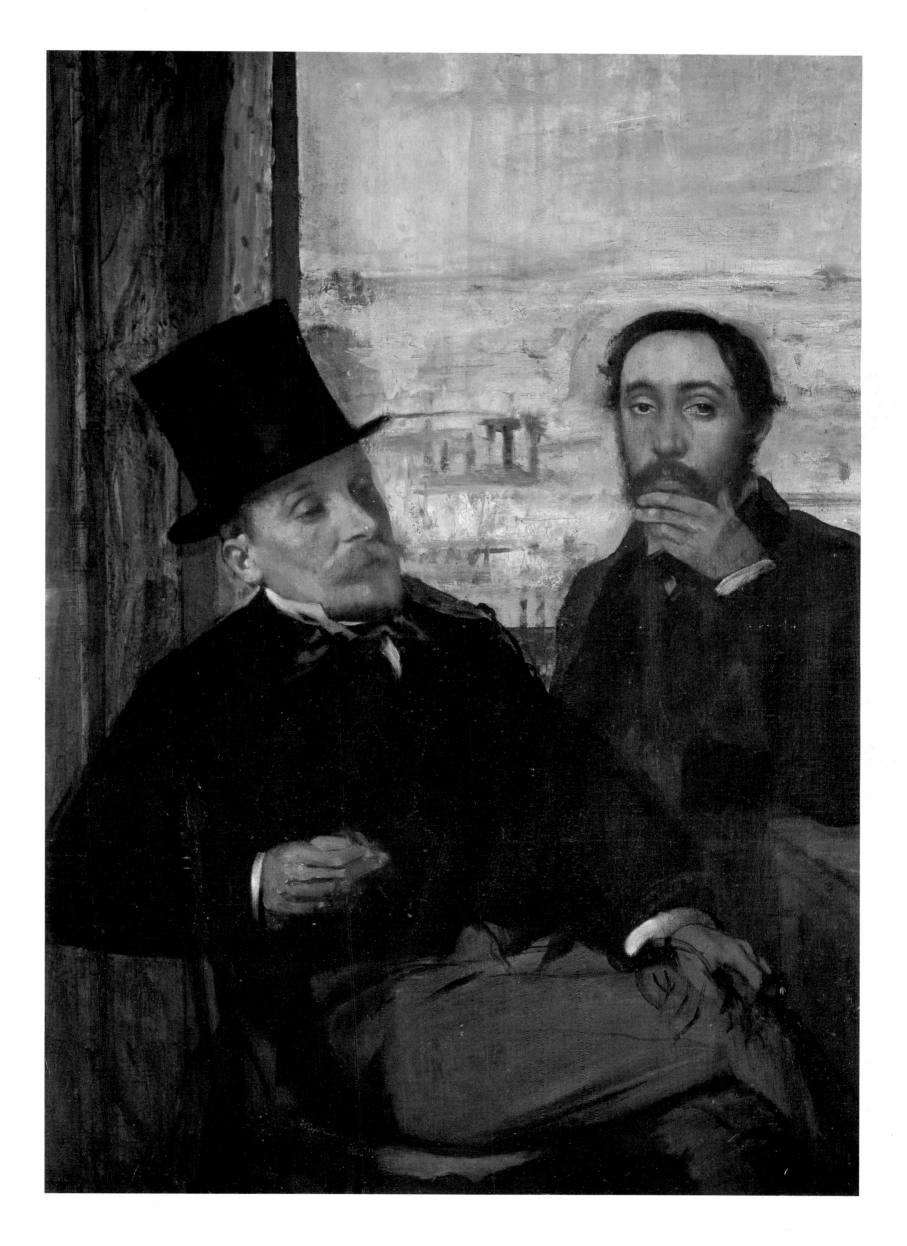

1. *Edgar Degas and His Friend Evariste de Valernes.* c.1865. Oil on canvas, 45⅝ × 35".
Musée d'Orsay, Paris. Erich Lessing/Art Resource, New York

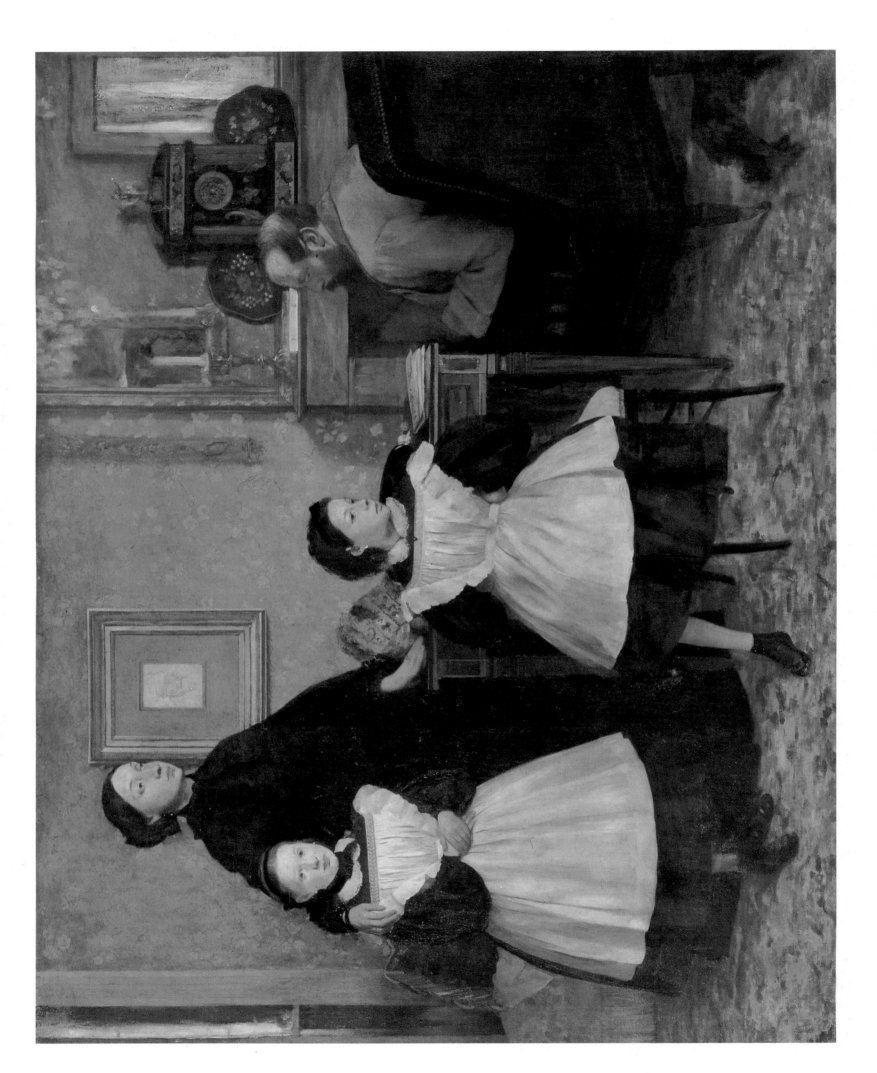

2. *The Bellelli Family*: c.1858–1860 (with later revisions). Oil on canvas, 78¾ × 98⅜".
Musée d'Orsay, Paris. Giraudon/Art Resource, New York

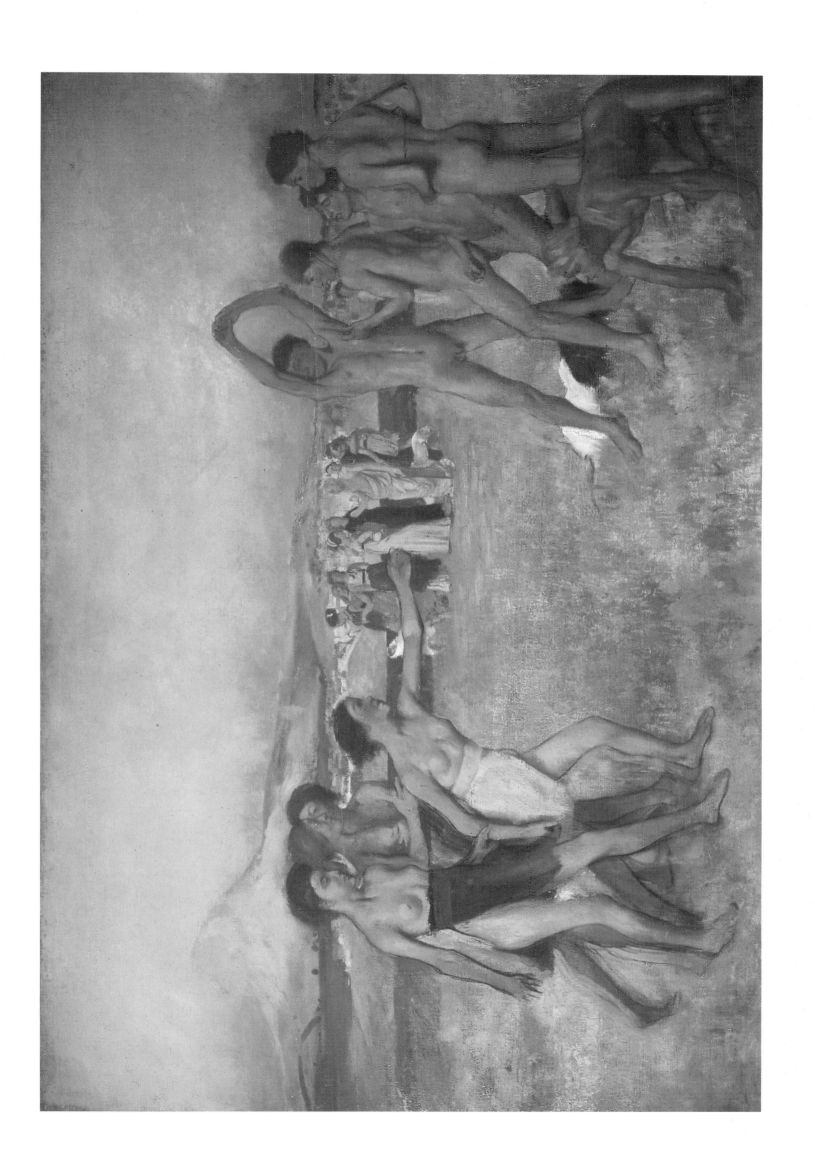

3. *Spartan Girls Challenging Boys.* c.1860/1880. Oil on canvas, 42⅞ × 61".
National Gallery, London. Bridgeman/Art Resource, New York

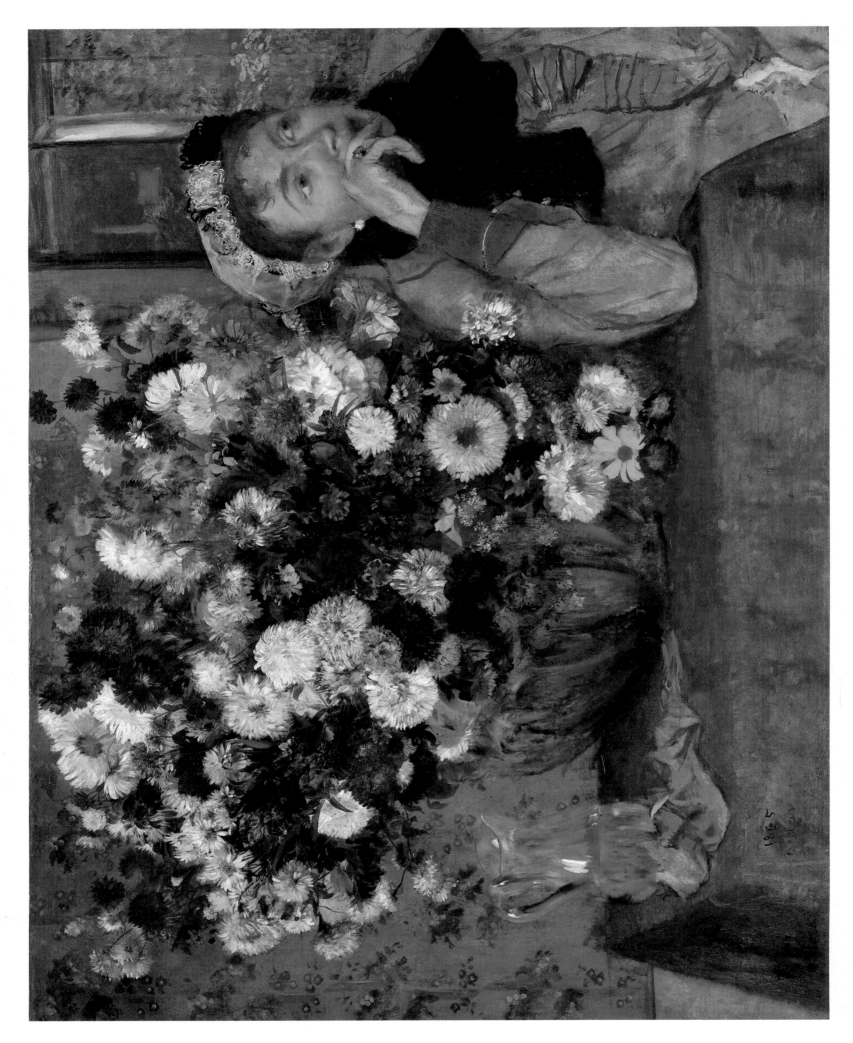

4. *Woman with Chrysanthemums (Madame Paul Valpinçon?)*. 1865. Oil on canvas, 29 × 36½".
The Metropolitan Museum of Art, New York. H. O. Havemeyer Collection, Bequest of Mrs. H. O. Havemeyer, 1929
(29.100.128). ©1980 by The Metropolitan Museum of Art

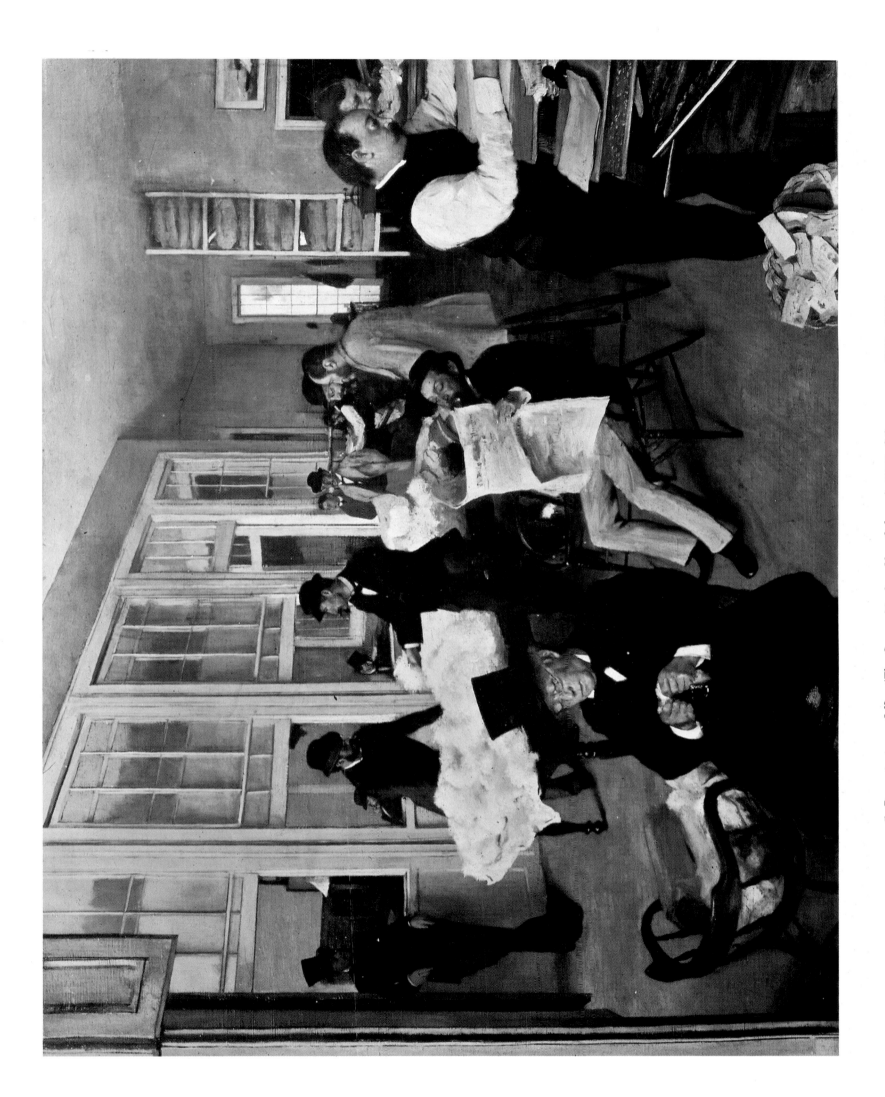

5. *Portraits in an Office (The Cotton Market, New Orleans)*. 1873. Oil on canvas, 28⅜ × 36¼".
Musée des Beaux-Arts, Pau, France. Giraudon/Art Resource, New York

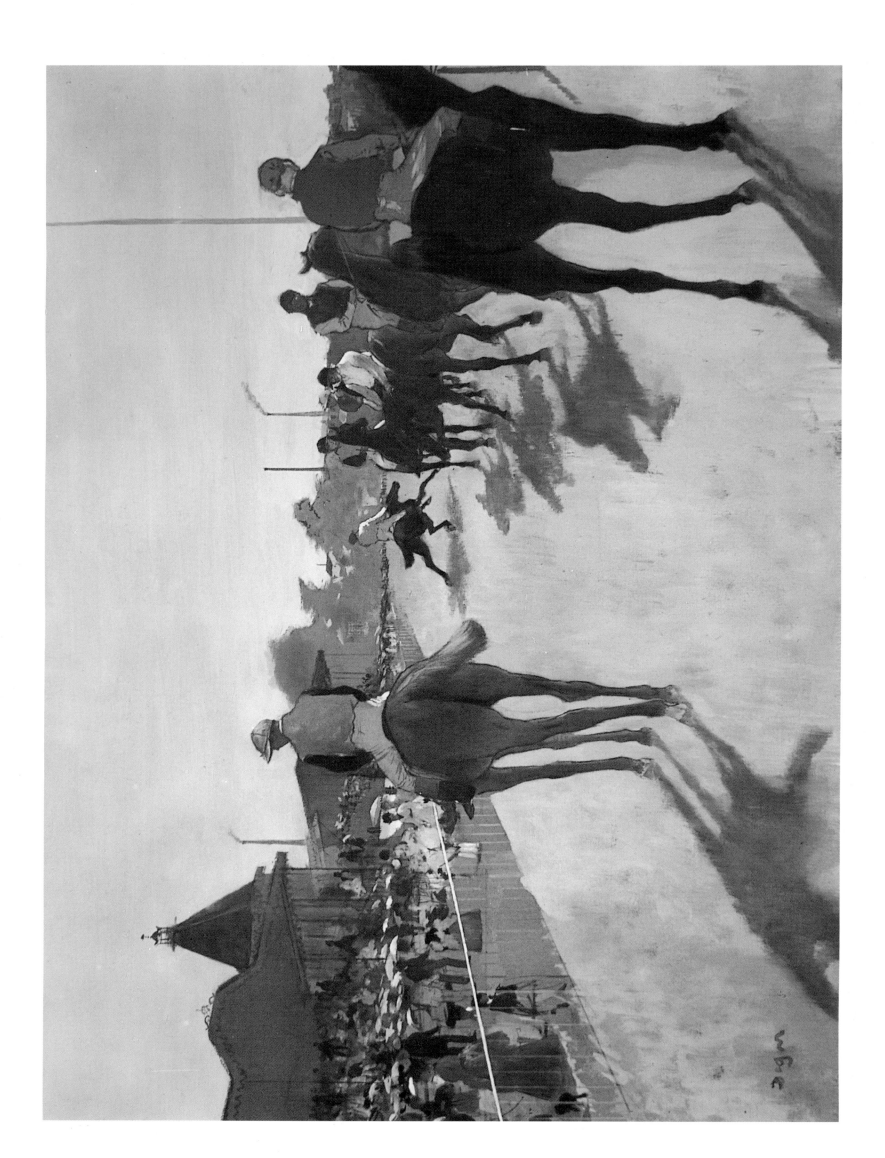

6. *Racehorses before the Stands.* c. 1866–1868. Essence on paper mounted on canvas, 18⅛ × 24".
Musée d'Orsay, Paris. Scala/Art Resource, New York

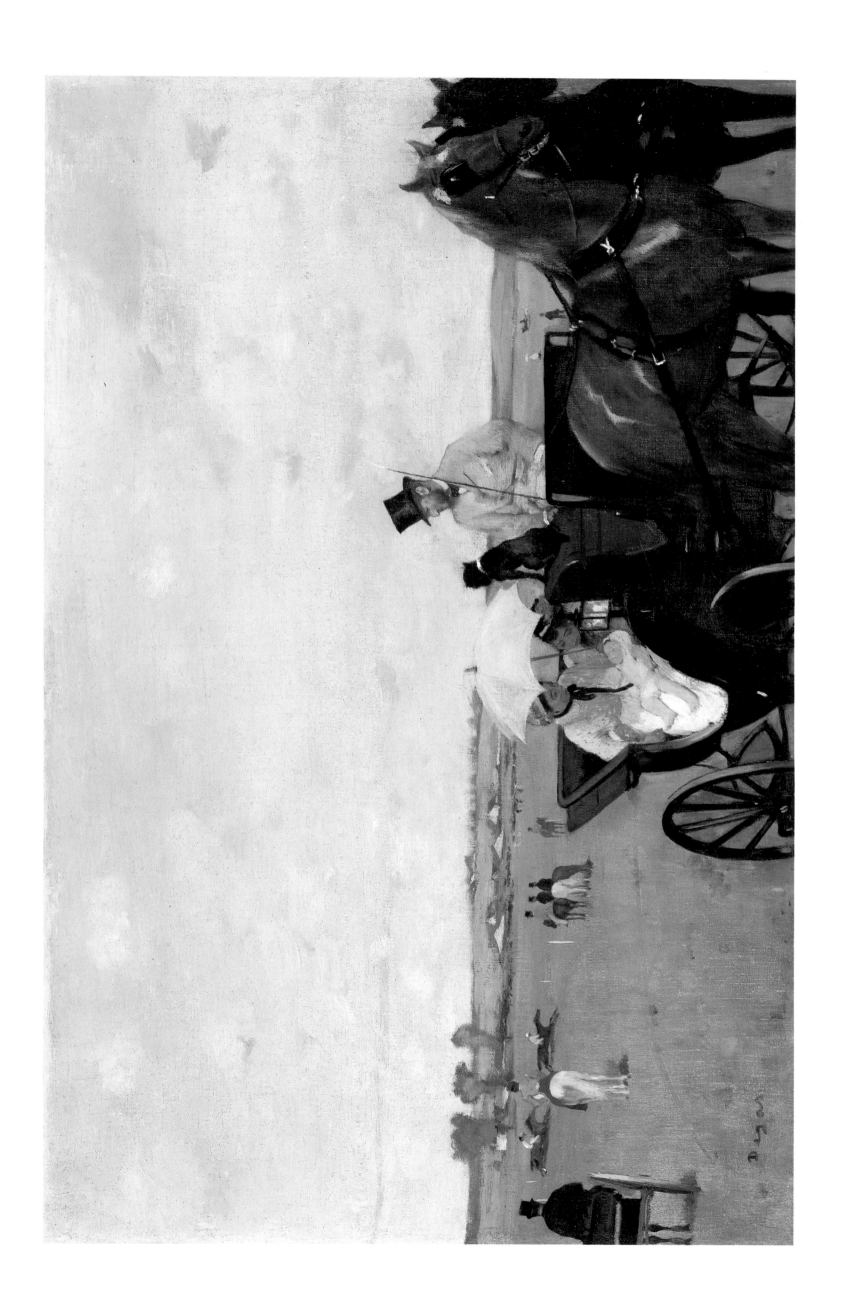

7. *At the Races in the Countryside.* 1869. Oil on canvas, 14⅜ × 22″. Courtesy, Museum of Fine Arts, Boston. 1931 Purchase Fund

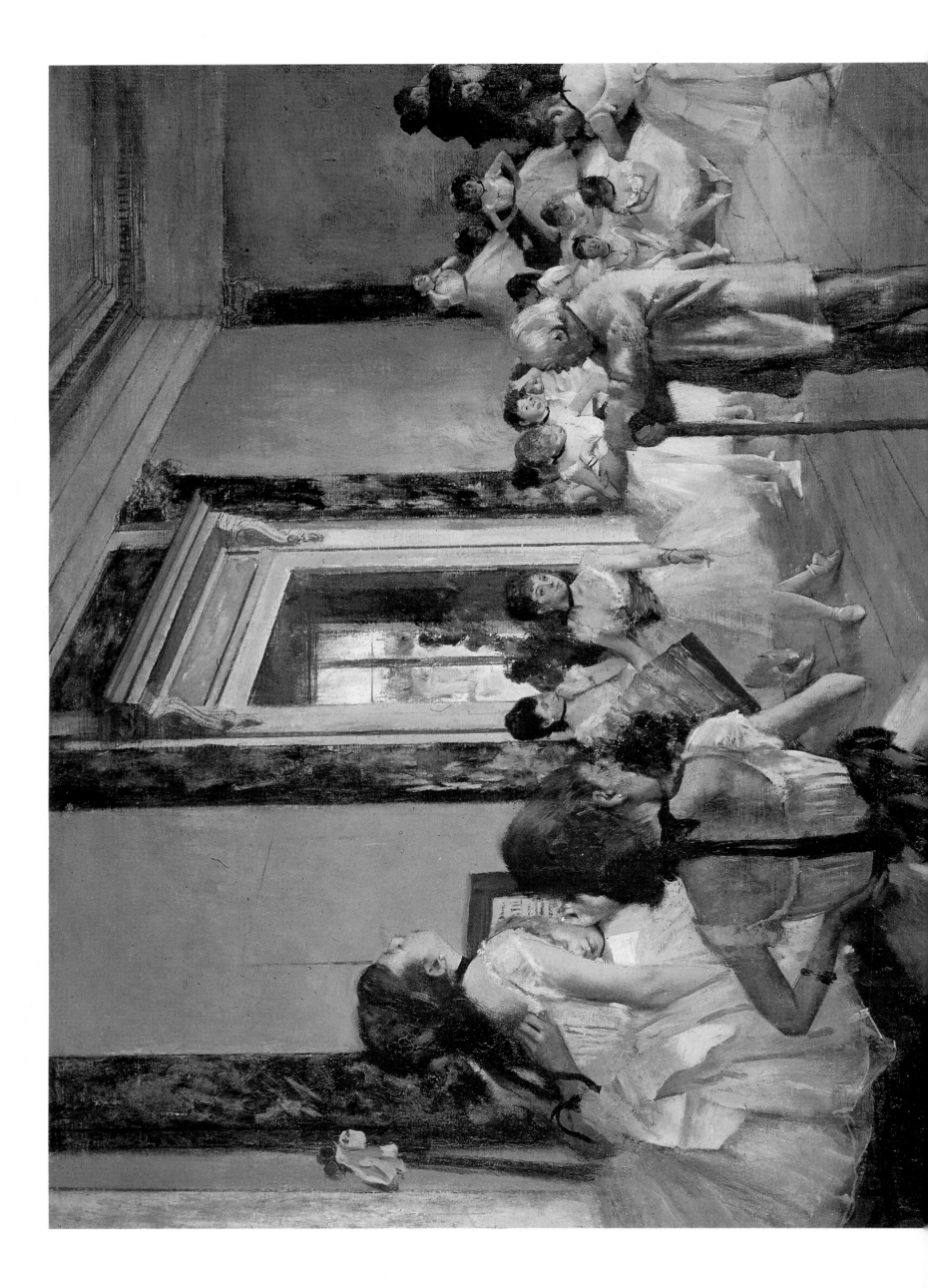

8. *The Dance Class.* c. 1873–1876. Oil on canvas, 33½ × 29½".
Musée d'Orsay, Paris. Giraudon/Art Resource, New York

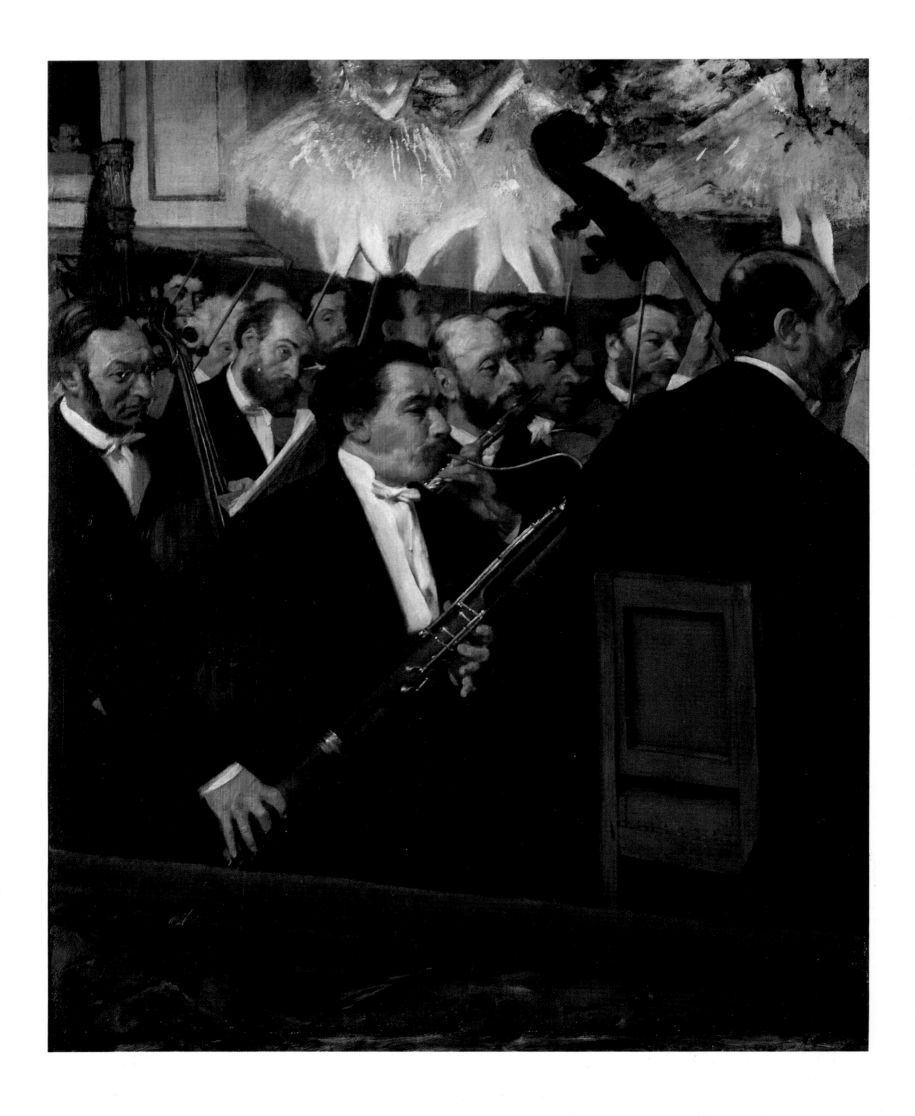

9. *The Orchestra of the Opéra.* c.1870. Oil on canvas, 22¼ × 18¼".
Musée d'Orsay, Paris. Scala/Art Resource, New York

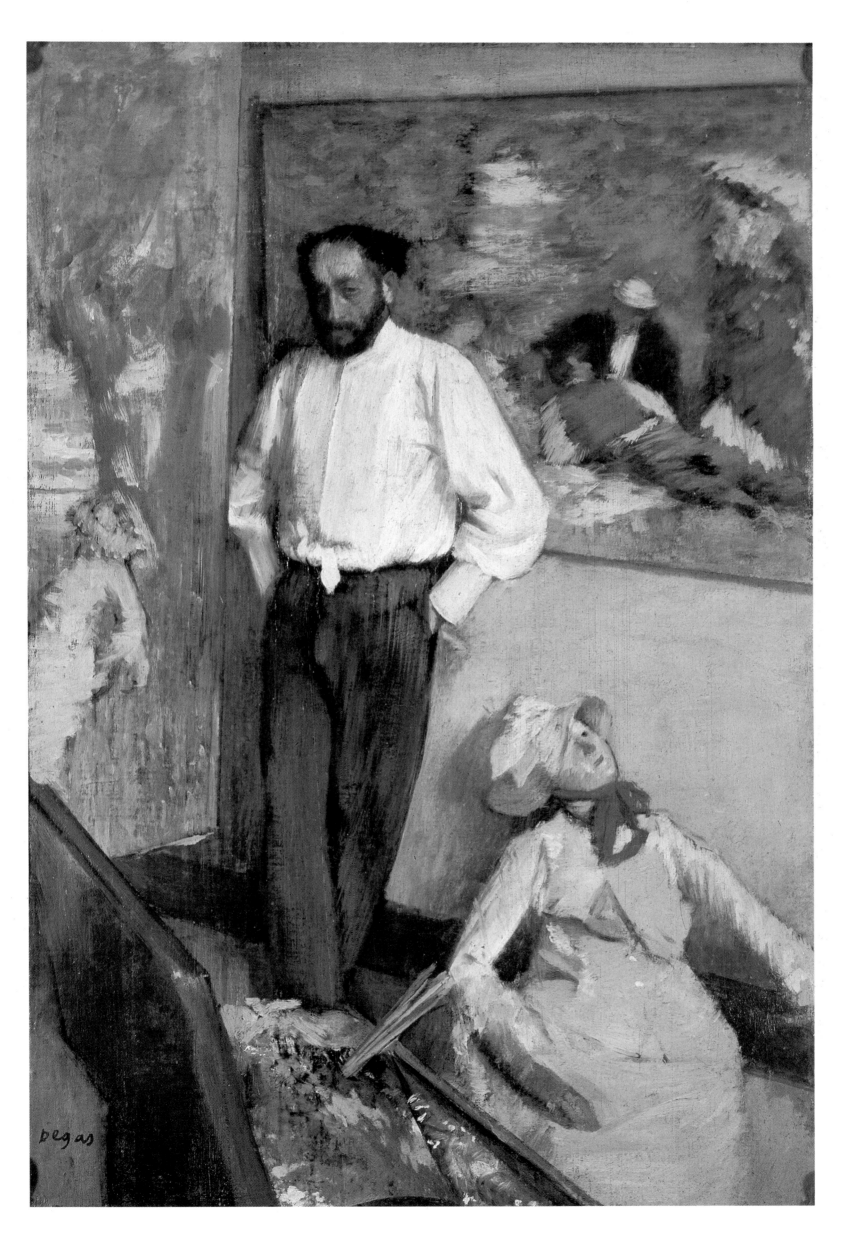

10. *The Artist Henri Michel-Lévy in His Studio.* 1878. Oil on canvas, 16⅛ × 10⅝"
Museu Caluste Gulbenkian, Lisbon. Bridgeman/Art Resource, New York

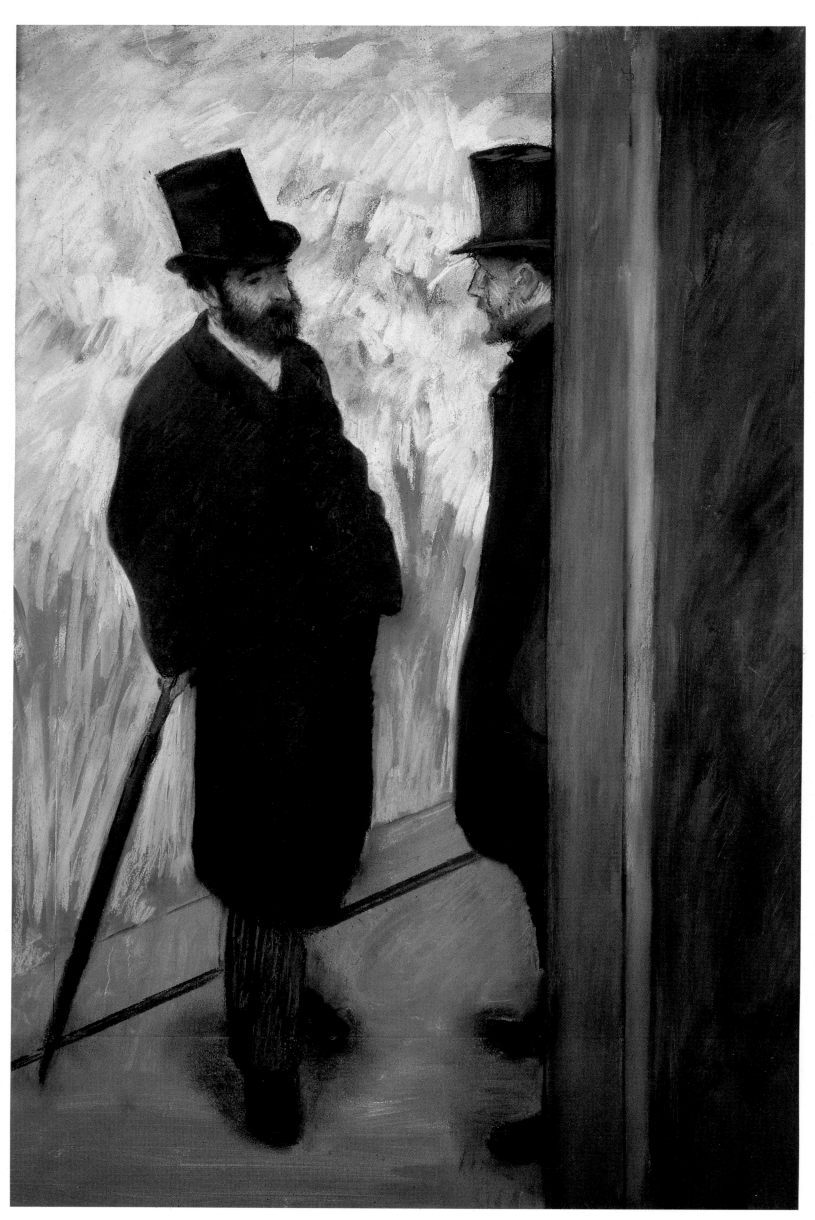

11. *Portrait of Friends in the Wings (Ludovic Halévy and Albert Cavé).* 1879. Pastel (and distemper?)
on five pieces of tan paper joined together, 31⅛ × 21⅝". Musée d'Orsay, Paris. Photo ©R.M.N.

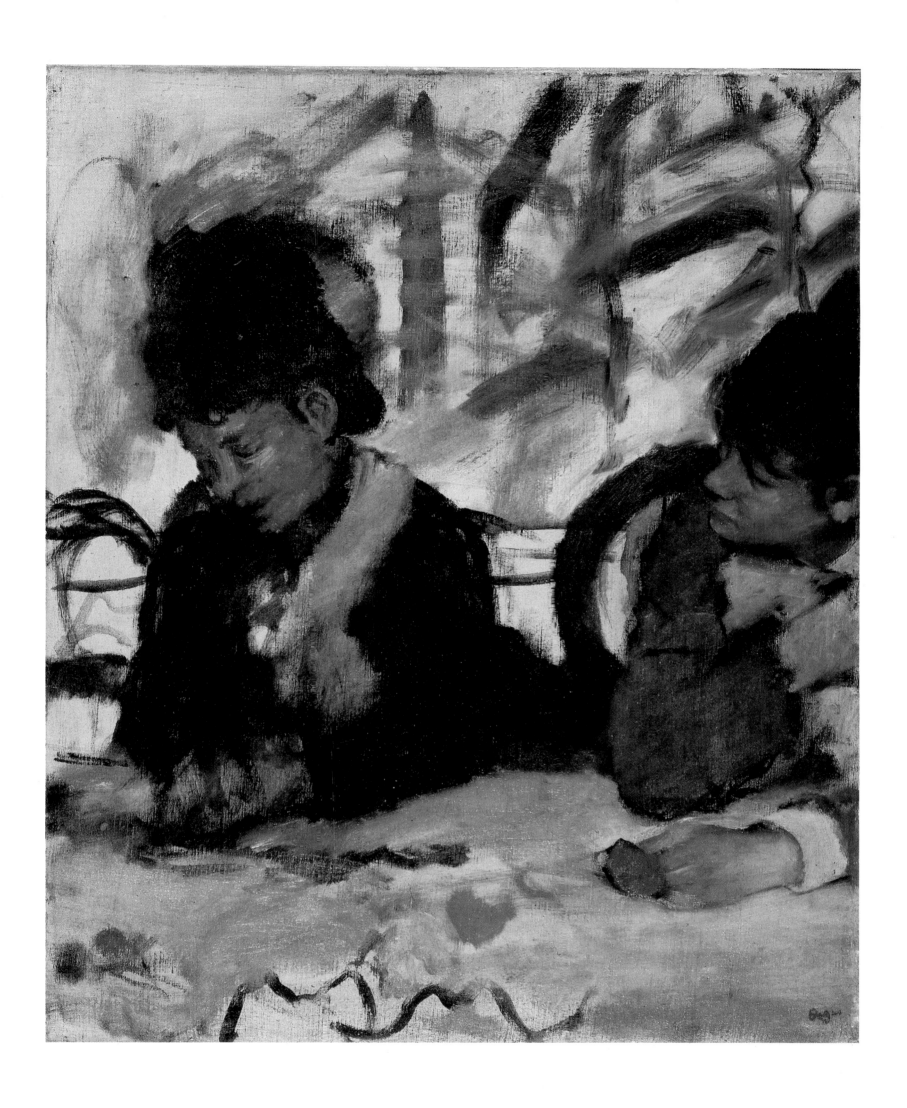

12. *At the Café.* c.1877–1880. Oil on canvas, 25⅞ × 21½".
Fitzwilliam Museum, Cambridge, England

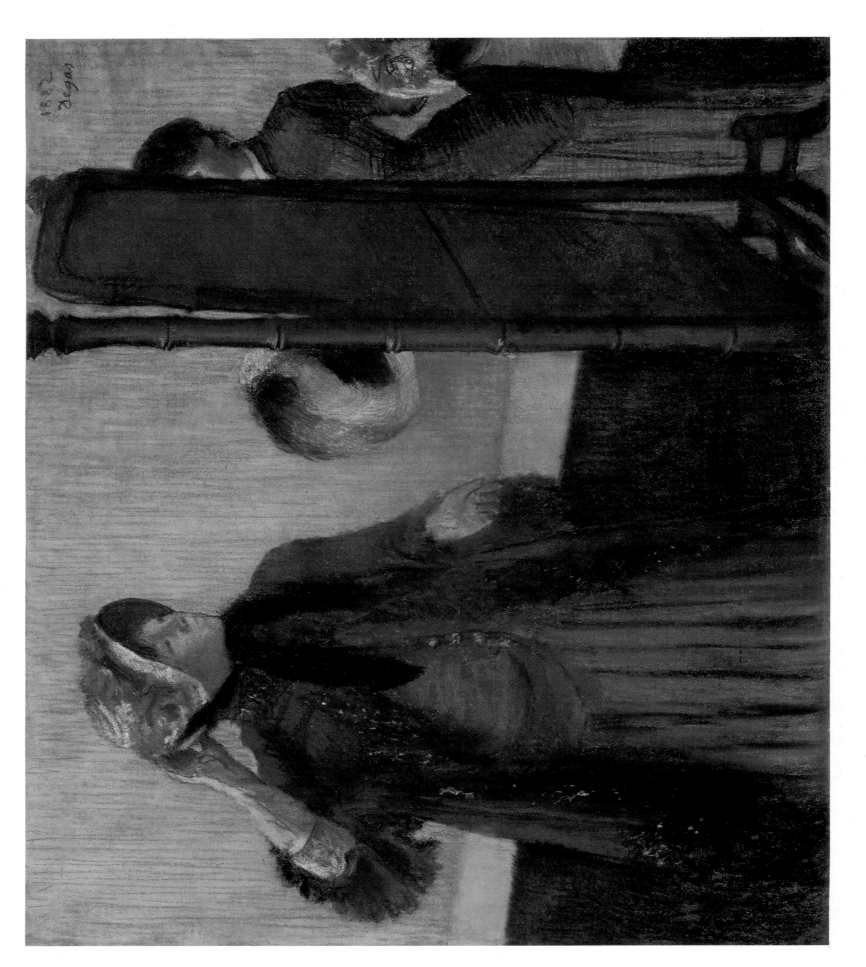

13. *At the Milliner's*. 1882. Pastel on paper, 29⅜ × 33⅜". The Metropolitan Museum of Art, New York. H. O. Havemeyer Collection, Bequest of Mrs. H. O. Havemeyer, 1929 (29.100.128). ©1987 by The Metropolitan Museum of Art

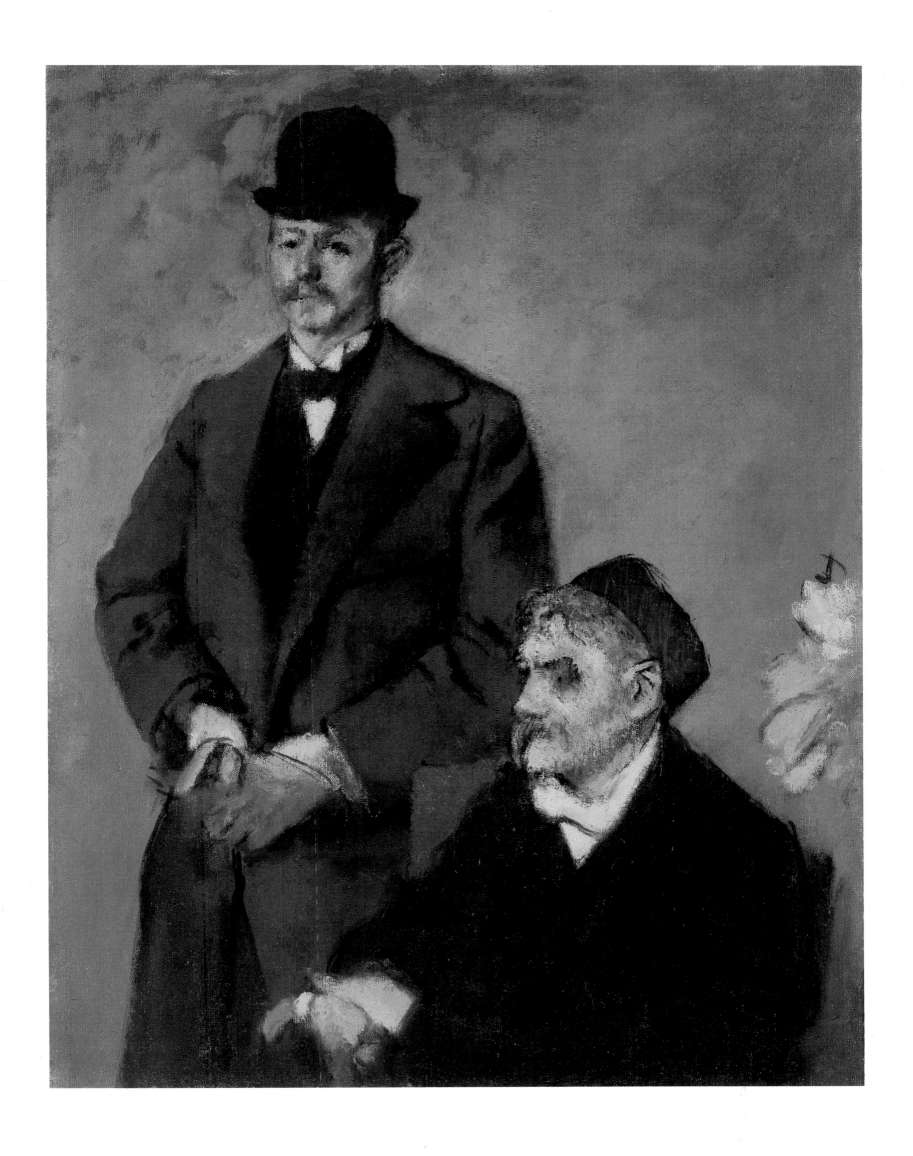

15. *Henri Rouart and His Son Alexis.* c.1895–1898. Oil ⊤ canvas, 36¼ × 28¾".
Neue Pinakothek, Munich. Photograph by Joachim Bla⊐el/Art⊙heck, Peissenberg, Germany

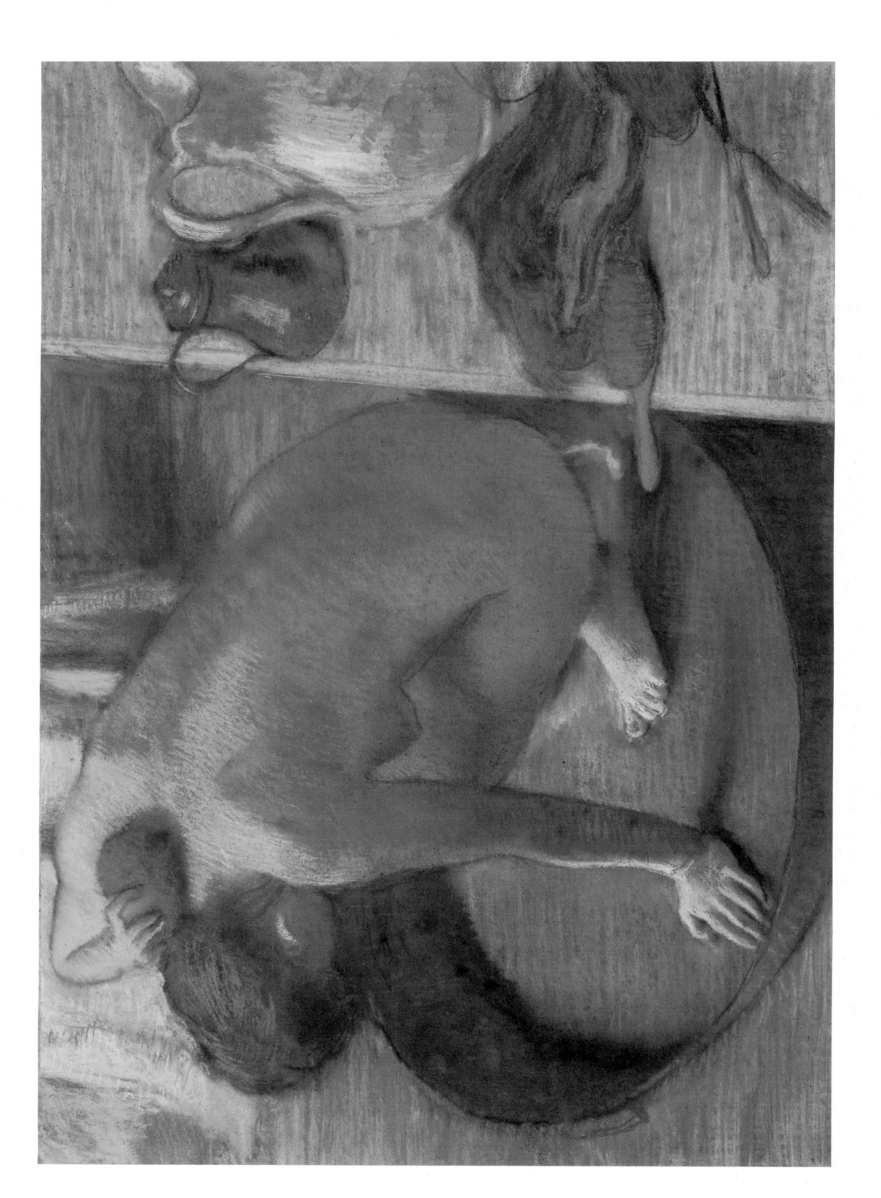

14. *Woman Bathing in a Shallow Tub*. 1886. Pastel on paper, 23⅞ × 32⅝". Musée d'Orsay, Paris. Giraudon/Art Resource, New York